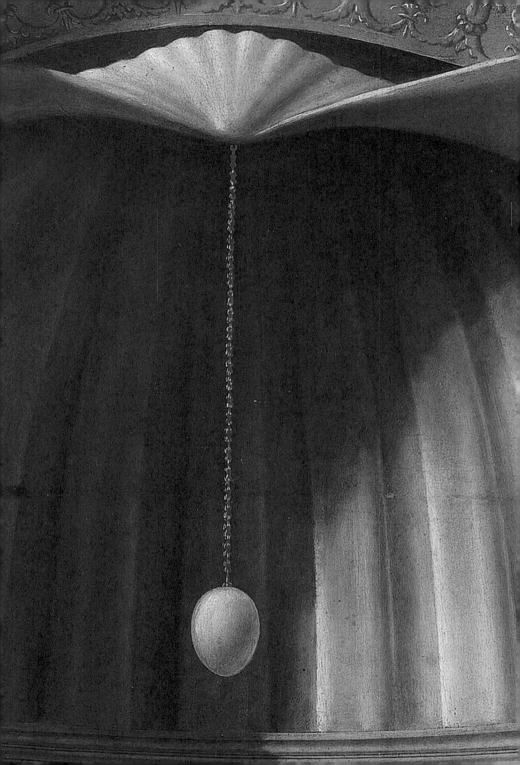

ART MYSTERIES

PIERO DELLA FRANCESCA

The Montefeltro Altarpiece

Marco Carminati

24 ORE Cultura

Production and publication
24 ORE Cultura srl

Publishing director
Natalina Costa

Head of planning
Balthazar Pagani

Editor-in-chief
Giuseppe Scandiani

Editing
Monica Sessa Vitali

Technical coordinator and head of graphics
Maurizio Bartomioli

Graphic design and layout
Mauro Petruccelli

Head of iconographic department
Gian Marco Sivieri

Picture research
Alessandra Murolo

Photolithography
Valter Montani

Editorial secretariat
Elisabetta Colombo

English translation
Felicity Lutz for Scriptum, Rome

First edition February 2012
ISBN 978-88-6648-089-1

CONTENTS

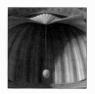

THE ARTIST COMES
BEFORE THE WORK

For us today the *Montefeltro Altarpiece*, held
by the Pinacoteca di Brera in Milan, is the
"Piero Altarpiece" par excellence. It therefore
comes as a great surprise to learn that, by contrast, until
the end of the 19th century no one even dreamt of
attributing this impressive masterpiece to Piero della
Francesca. For centuries people were firmly convinced
that the painter of this work was a certain Bartolomeo
Corradini, a Dominican friar and artist known by
his funny nickname Fra Carnevale. The *Montefeltro
Altarpiece* entered the Brera with this attribution
in 1811 and in all the catalogues of the Milanese gallery
it was assigned to Fra Carnevale until the end of the
19th century.
How did this come about? The explanation is simple:
Piero della Francesca had merely been simply forgot-
ten. His name and his works had slowly ended up buried
under the dust of oblivion until they disappeared from
the horizon of history. After Giorgio Vasari's last words
of praise in the mid-16th century describing Piero as
a "great master of the problems of regular bodies, both

arithmetical and geometrical", the painter sank into total disregard until all trace of him was lost.

He was resurrected by critics at the dawn of the 20th century, thanks to the studies undertaken by Bernard Berenson, Adolfo Venturi and Roberto Longhi, who brought the master back into the empyrean of the great. This was a revival that started from an analysis of forms. Berenson was struck by "the painter's impersonality, the absence of emotions, the quality of things", and added that "the solemn figures, the calm actions, the severe landscapes exert their maximum power over us". Without departing from a formal reading, Adolfo Venturi attempted to set the artist more concretely in the context of his time and Roberto Longhi, his pupil, increased our in-depth knowledge of Piero in his memorable writings, an article of 1914 and a monograph of 1927. Longhi not only described Piero's greatness in a remarkably pithy sentence ("Piero is the perspectival synthesis of form and colour"), but he also noted his modernity and the possibility of comparing his works to those by

Cézanne or Carrà, as well as the powerful influence
he had on the Italian art that was becoming defined in
those early decades of the 20th century.
The abstract purity of the volumes, the artificial
brightness of the colours, the diffusion of still light,
the mathematical precision of the perspectives and
the architecture are all elements that we find in this
Brera altarpiece and that make a great impression on
us. So do the symbols that we note in the work and
that "speak" to us, first and foremost that striking egg
suspended above the Virgin Mary's head.
It must be underlined that it was not until after
World War II that Piero della Francesca's works began
to be interpreted not only with reference to the forms,
but through in-depth iconographic, iconological
and documentary readings. This began with Millard
Meiss's attempt in 1954 and again in 1972 to deci-
pher the mysterious symbolism of the *Montefeltro
Altarpiece*, which we shall discuss below.
Unfortunately, the documents that have gradually come
to light from the archives over the last hundred years

(above all those published by Eugenio Battisti in 1971 and by James Baker in 1993 and 2001) have not done a great deal to solve the main problem as regards Piero della Francesca, which is the correct chronological sequence of the works. In fact, there is a lack of incontrovertible documentary evidence for nearly all his works, consequently the chronology of Piero's paintings is always a choice that has to be made from a considerable number of different possibilities. However, the documents that have emerged from the archives have been very useful in establishing who this extraordinary artist really was. Thanks to these archival papers, Piero has come down from the pedestal of excessive idealization and has more concretely and correctly been placed within the context of his time. We see him fully breathing in the culture that surrounds him, starting his career "at the bottom" as a painter of standards and flags, and later "stealing" ideas from the pioneers of the Florentine Renaissance and the pioneers of Flemish art. Then we observe him living supported by the solid mercantile values of his family and we see him directly engaged in

the management of public affairs and holding prestigious offices in his birthplace Borgo San Sepolcro. We also catch him out, at one point, being very late paying his taxes. And then we realize that he used all the wiles of an astute businessman and bought a lot of houses and land, and also weighed himself down with commissions so as not to lose them, but then could not respect the contracts and sometimes delivered the works decades late.

When the light of oblivion swallowed up Piero the painter, the torch of fame only remained burning above his theoretical writings. Piero wrote three books: a book on accounting, a treatise on perspective for painters and a more complex work devoted to regular solids. This is hardly surprising, since accounting and perspective were among the hot subjects of the cultural debate in 15th-century Italy. All his life he considered painting the natural, almost practical, outcome of his studies and abstract meditation, and transferred to his paintings – in a way no one in his time was able to – the golden rules expressed in his treatises. We only have to observe the *Montefeltro Altarpiece* closely to see the truth of what we have said above.

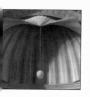

THE STATE OF PRESERVATION
OF THE *MONTEFELTRO ALTARPIECE*

T he interpretation of every work of art – as
the great Federico Zeri taught us – must
begin from an examination of its state of
preservation. Despite appearances, the *Montefeltro
Altarpiece* (oil on panel, 251 x 172 cm), did not
come down to us in excellent condition. The lengths
of wood that make up the panel bear the marks of its
past vicissitudes. Its violent removal from the Church
of San Bernardino in Urbino by Napoleonic func-
tionaries and the rough journey to Milan in a cart,
in 1811, may have caused the long gash across the
back of the panel, where several attempts have been
made to clumsily patch it up. It is also possible that
the damage may have happened earlier, for instance
during the two earthquakes that shook Urbino in
1741 and 1781. Further injuries inflicted on the
panel are the result of its having been reduced in size:
it has been observed that the edges of the *Montefel-
tro Altarpiece* have been cut down three times. A few
centimetres have been removed both on the right and
on the left hand side (though to a lesser extent here),

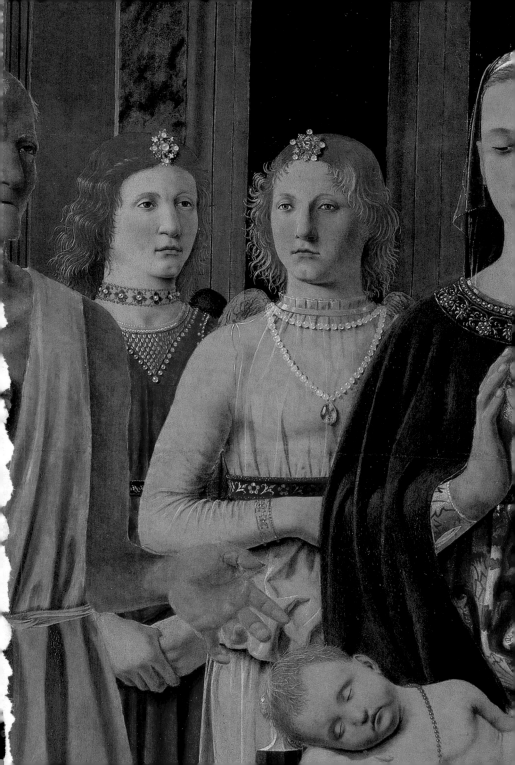

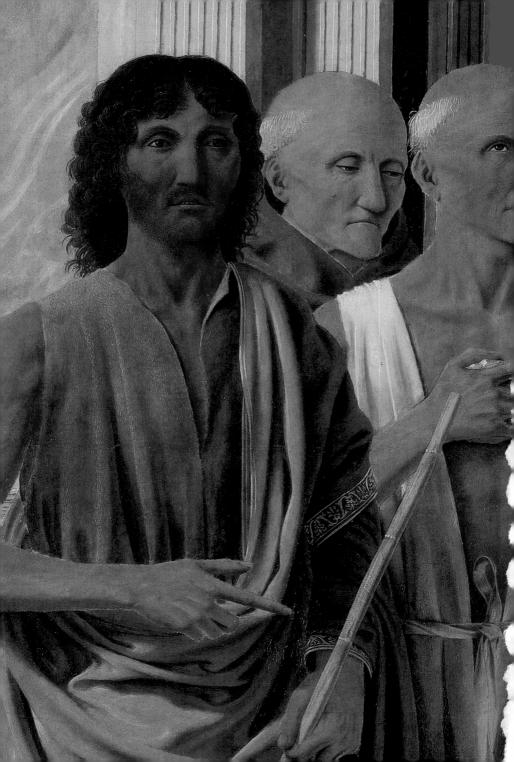

"The deification of man is the triumph of Humanism, and because of this Piero della Francesca's altarpiece is a synthesis of the spiritual culture of the 15th century … The still, fixed light in the museum [Pinacoteca di Brera] eliminates some of the variations and vibrations of that enchanted silvery light that bathes the architecture and models the forms; only someone who has seen Piero's work in a free atmosphere can have any idea what a miracle it is. And yet even the most distracted visitor realizes … that these rare volumes by Piero della Francesca have been achieved by condensing, in plastic planes, the arcane coloured ether of which the whole atmosphere is woven ... And we are moved by the sublimation of the pictorial genius of Piero della Francesca, nourished by the highest science and philosophy of the Renaissance ..."

Fernanda Wittgens, *La pala urbinate di Piero*, Milano 1952

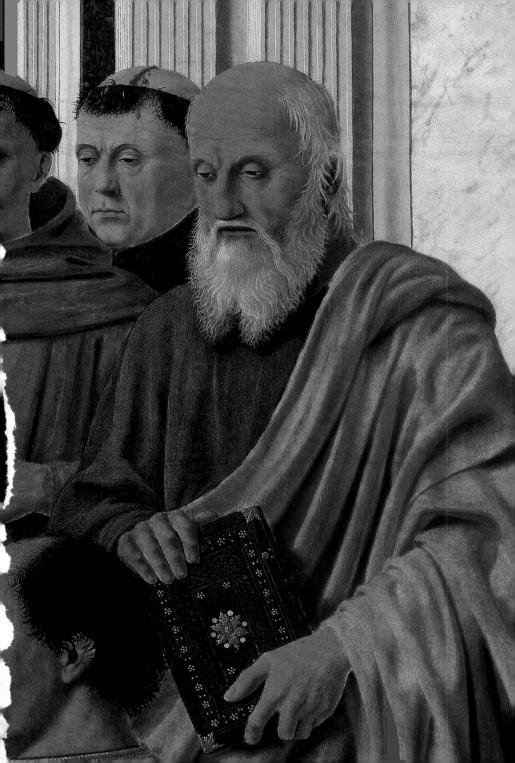

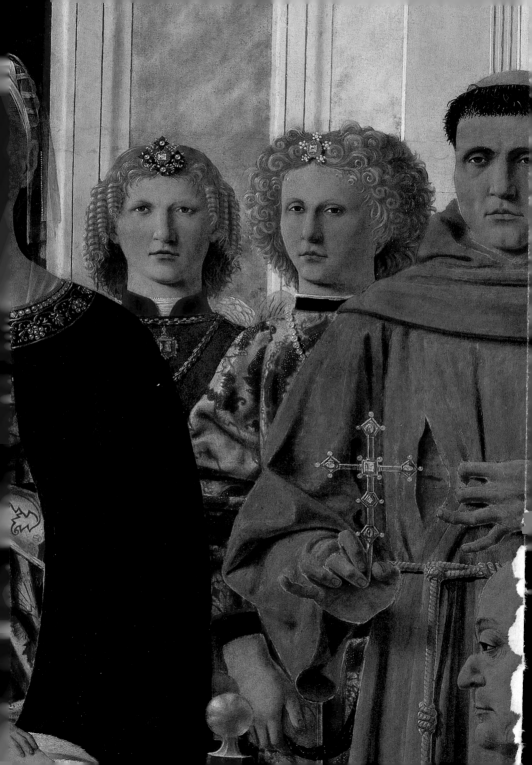

while the bottom edge is missing one of the horizontal planks that make up the panel. We have to take these mutilations into account because – as we shall see later – they have certainly had a negative effect on the interpretation of the painting, its spatial layout and the relationship between the figures and the architecture.

The *Montefeltro Altarpiece* was radically restored in 1980–1981 by Pinin Brambilla Barcilon. On that occasion and when it was touched up several times in the 19th century, particularly around the Virgin's eyes, the old yellowed pigments were removed.

The restoration work also revealed that some areas of the panel were not completed by Piero della Francesca, that some details were erased (like the jewel on the Virgin's brow) and that others were completely reworked (like Federico da Montefeltro's hands).

On turning the panel over and studying the workmanship – it consists of nine horizontal planks of poplar wood held together by unusual metal pins with eyelets –it was seen that the way it had been

assembled was absolutely original and is found in only two other works from Urbino: the series of *Illustrious Men* in the Studiolo in the Palazzo Ducale and the *Communion of the Apostles* by Justus of Ghent. Since we know that the above-mentioned works were part of very vast and complex decorative schemes, we can deduce that Piero's altarpiece must also have been assembled with a view to its being part of a vast and complex decorative scheme, which has now been irremediably lost.

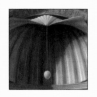

ONE ALTARPIECE
AND TWO QUESTIONS

W ho was the *Montefeltro Altarpiece* executed
for? And when?
Before answering these questions let's
focus on the painting and try to describe it. Within a
Renaissance architectural space resembling a church,
richly decorated with inlaid polychrome marbles,
Federico da Montefeltro, Duke of Urbino, seen in
profile (his unmistakable aquiline profile), dressed
in armour and kneeling, has placed before him –
as though they were votive offerings – his staff of
office, gauntlets and helmet. With hands joined he
is worshipping the Virgin Mary and the Christ Child
asleep in her lap. Jesus has a coral necklace around
his neck, namely the symbol of the blood he will shed
during his Passion for the salvation of mankind.
Mary is seated at the centre of the composition,
flanked by six saints and four archangels. The saints
on the left are St John the Baptist the Forerunner
(whose right hand is pointing to Christ), St Bernardi-
no of Siena (the titular saint of the church where the
altarpiece was to be placed) and St Jerome beating his

chest and clothed in rags. On the right of the Virgin is St Francis with the stigmata in his side, St Peter Martyr with the wound on his head and St John the Evangelist holding the Gospel. In the middle ground, behind the Virgin, the four figures of angels (recognizable by the wings sprouting from their shoulders) are characterized by sumptuous garments, precious jewels and spectacular decorative hair clips on their elaborate hairstyles.

This panel is often given the title *Sacred Conversation* though it is very obvious that no one is conversing. But let's now deal with the questions. For whom and when did Piero execute this wonderful painting? The few documents concerning Piero that have survived assure us that on 8 April 1469 the painter was definitely in Urbino, the guest of Giovanni Santi (Raphael's father). This modest Urbino painter had a certain influence among the city's artists. It was he, in fact, who put Piero della Francesca in contact with the local Brotherhood of Corpus Domini, who wanted to commission from him a large altarpiece with the

Communion of the Apostles, which both Fra Carnevale and Paolo Uccello had left unfinished (the latter had only executed the predella, now in the Galleria Nazionale delle Marche, Urbino). We know that Piero did not accept the commission and it was successfully assigned to the Flemish painter Justus of Ghent, who was active at the Urbino court. However, this contact opened wide the doors of Urbino and its court to Piero. Vasari tells us that the painter had already come to the city in his youth, when he was active in Ferrara and later in Rimini. Now Piero returned to the Montefeltro capital at the height of his fame and artistic maturity (marked by the *Legend of the True Cross* in Arezzo), and he found himself working in a city in full architectural and cultural expansion, which was ambitiously aiming to become one of the centres of the Italian Renaissance. Duke Federico da Montefeltro, condottiere and General Captain of the Church, was at the peak of his civil and military power, and certainly wanted to set a seal on his success and hand it down to posterity by inviting hosts of architects, painters,

sculptors, miniaturists and inlayers from all over Italy, Flanders and Spain to execute works at his court high up in the Apennines. He commissioned the Dalmatian Luciano Laurana to design the vast Palazzo Ducale. Construction began in 1468 and was completed around 1472, and Baldassarre Castiglione described it as "not a palace but a city in the form of a palace". To decorate this "city in the form of a palace" the duke employed skilful inlayers who used cartoons by Botticelli, Baccio Pontelli, Benedetto da Maiano and Bartolomeo della Gatta, to make the wonderful doors of the rooms and especially to work on the private Studiolo where the duke loved to pursue his humanistic studies, in the free time allowed him from his military exploits. Here he read the beautiful codices that he commissioned from the best miniaturists, particularly those active in Florence. In this small room he would gaze at the many panels of portraits of illustrious men of the past by the Flemish painter Justus of Ghent. In the adjacent rooms, perhaps mounted on wooden supports, there were fine displays of panels with impressive city-

scapes characterized by majestic Renaissance perspecti-
val architecture, called "Ideal Cities".
The duke also planned for the afterlife and
summoned the architect Francesco di Giorgio Marti-
ni to Urbino to design his mausoleum, the Church of
San Bernardino outside the city.
When he went through the gates into Urbino, Piero
found himself in the midst of this exciting creative
ferment and he was sure he could successfully carve
out a niche for himself. It was the duke in person
who made this possible by recognizing his exceptional
talent and assigning him two commissions of prime
importance: his official portrait with his wife Battista
(now in the Uffizi) and the large *Montefeltro Altarpiece*
in the Pinacoteca di Brera.
In all likelihood Federico da Montefeltro commis-
sioned this votive-funerary offering altarpiece from
Piero for his mausoleum designed to be built outside
Urbino. Piero soon began work on the altarpiece,
while the church itself was not constructed until after
the duke's death in 1482. This is an important fact,

because it may explain why the artist did not finish the painting and why others intervened to complete it, as in the case of the duke's joined hands, which were reworked by a northern master, either Justus of Ghent or Pedro Berruguete (a Hispano-Flemish painter at the Urbino court during that period). Those who subsequently worked on the altarpiece also erased some details, such as the jewel on the Virgin's brow, now inexplicably hidden under new paint.

Whilst waiting to be placed in the Church of San Bernardino the altarpiece must have found a temporary home. Some scholars suggest that this may have been San Donato degli Osservanti, the traditional church of the dukes of Urbino (where Federico's body was housed before being transferred to San Bernardino); others have thought it was the Church of San Francesco, where the earthly remains of the duke's wife Battista Sforza, had been laid to rest.

When exactly Piero executed the altarpiece and its iconographic meanings still remain the subject of lively debate.

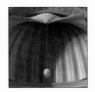

TWO FURTHER QUESTIONS

B
ut the questions about the *Montefeltro Altarpiece* do not end here. What does the egg hanging in the apse mean? And what is the meaning of the stunning architecture featured in the painting? The scene is set in the middle of a magnificent Renaissance building that appears to evoke the rooms in the Palazzo Ducale in Urbino, the Palatine Chapel and the large arches of the Loggia.

This architecture is enhanced by an impressive apsidal shell from which hangs a large egg on a chain. The interpretation that has received greatest consensus is the one proposed by Millard Meiss namely that the *Montefeltro Altarpiece* was executed between 1472, the year of the death of Duchess Battista Sforza, who is absent from the painting but "represented" by John the Baptist, and 1474, the year when the Orders of the Garter and the Ermine – which he is not wearing in the painting – were conferred on Federico. The huge egg that we see hanging from the chain is an ostrich egg. In the traditional medieval bestiaries ostrich eggs had a very unusual characteristic,

since they hatched without being fertilized. Hence they came to allude to Mary's Immaculate Conception. In this case the ostrich egg may also suggest the birth of the duke's heir Guidubaldo, which occurred just before his mother Battista died. Other scholars have noted that Federico is wearing armour, perhaps to celebrate the victory over Volterra in 1472, but he is not yet wearing the insignia of General Captain of the Church, an appointment he received in 1474. Naturally many objections have been raised against this interpretation and one of the most convincing has been put forward by Carlo Bertelli (he dates the painting to between 1469 and 1472) who notes, quite rightly, that many Renaissance votive altarpieces (such as, the *Madonna of Victory* by Mantegna) show the condottiere kneeling without his wife, but this does not mean that she is dead. According to Ronald Lightbown, however, Battista Sforza is absent because San Bernardino was not her burial place, and the famous egg hanging from the shell does not allude to the Immaculate Conception, but, if anything, to the

Easter symbol, understood as Federico's hope in the final reward of Resurrection.

To conclude, there have also been numerous attempts to decipher the secret of the harmonious architectural space in which this silent *Sacred Conversation* takes place. Architectural space was conceived unitarily by Piero della Francesca (and not by Bramante, as some people have thought). We are in a church and Mary, the *Mater Ecclesiae*, is the heart and focus of this architecture that was designed to be very much vaster than it now appears to the eye. In fact, it has been calculated that the figures are not in front of the apse where the two transepts meet, as it would seem at first glance, but farther forward, in a hypothetical nave, which could be better perceived before the sides and particularly the bottom edge – where a whole horizontal plank is missing – of the panel were shortened. Therefore in all likelihood, the *Montefeltro Altarpiece* originated as a votive altarpiece between the 1460s and the 1470s. Duke Federico da Montefeltro, in an attitude of prayer, turns trustingly to Mary, the

Mater Ecclesiae, and contemplates in her the mystery of the Incarnation and the Redemption evidenced by the Christ Child, offered as the sacrificial lamb in his mother's lap. The setting, however, is the physical reality of the Urbino of the time, which thanks to the duke's wise policies had acquired splendid Renaissance buildings in just a few years. It is not surprising that this masterpiece was placed above the altar in the Church of San Bernardino, close to Federico's tomb, in eternal memory of the faith and greatness of this munificent duke.

The Montefeltro Altarpiece

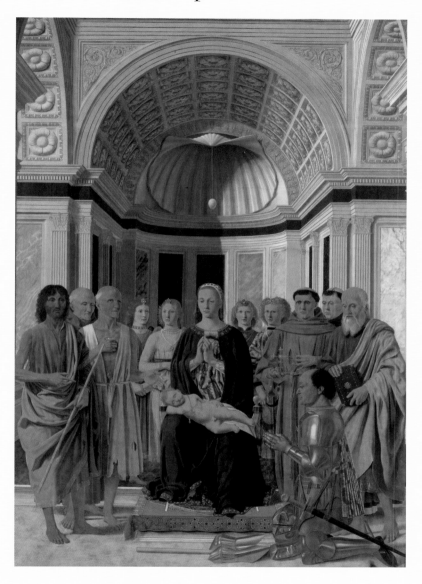

1469-1474
Tempera and oil on panel, 251 × 172 cm
Milan, Pinacoteca di Brera

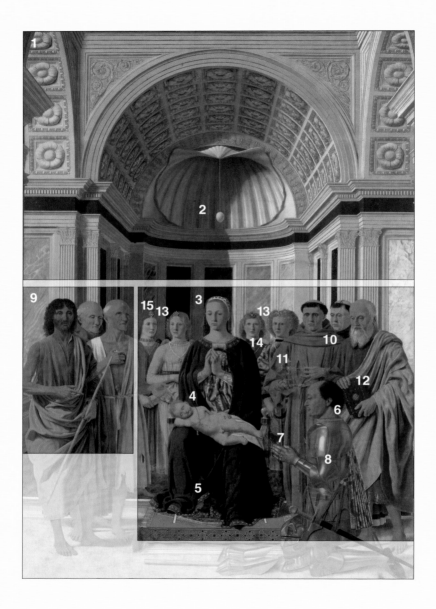

The architecture
in the painting

The spectacular setting in which the scene takes place echoes the extraordinary architecture that was the backdrop to Piero's work as a painter, from the buildings designed by Brunelleschi and Leon Battista Alberti, to those by Francesco Laurana, Bramante and Francesco di Giorgio Martini. The space seems to allude to a church with the form of a Latin cross wonderfully faced with polychrome marble, finely sculpted in part, with Pietra d'Istria white marble on the ceilings and pilaster strips, porphyry on the cornice and mixed marbles for the panels along the walls. The ceilings of the apse and the transepts appear to be coffered and decorated with sculpted rosettes. The apsidal bowl-shaped vault is occupied by a huge sculpted shell (the symbol of the Creation) from which hangs a chain with a giant egg. It has been noted that this architecture closely resembles some details of the palazzo in Urbino designed by Luciano Laurana (from the triumphal arches in the Torricini Loggia to the Palatine Chapel).

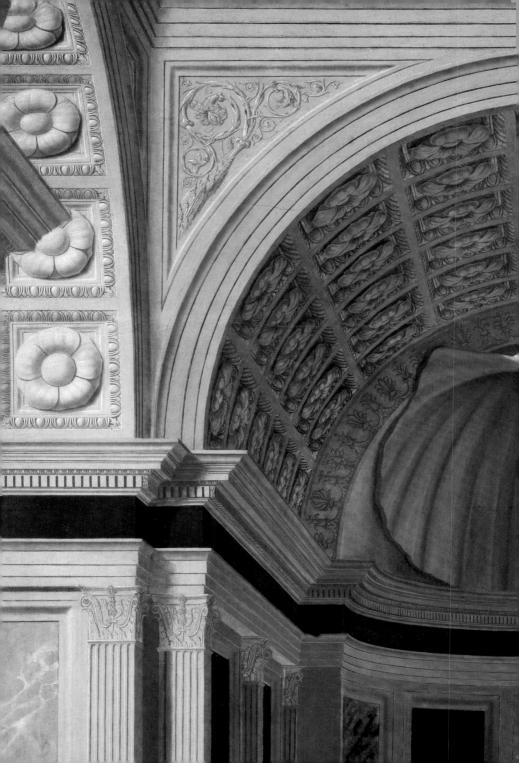

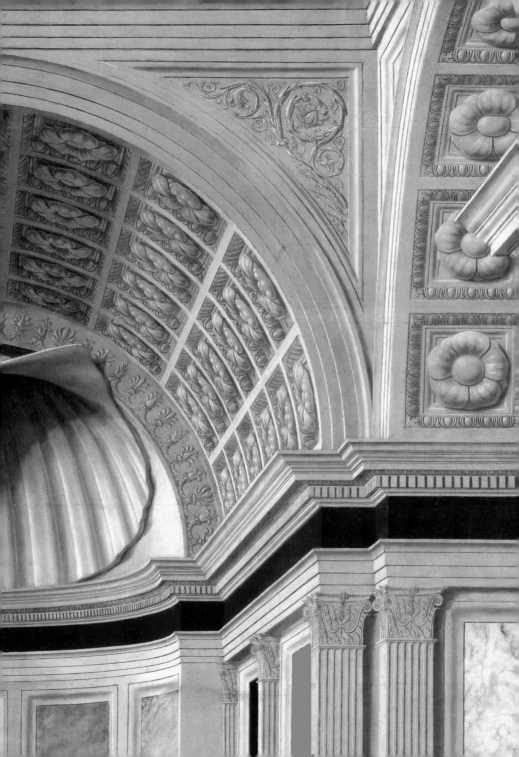

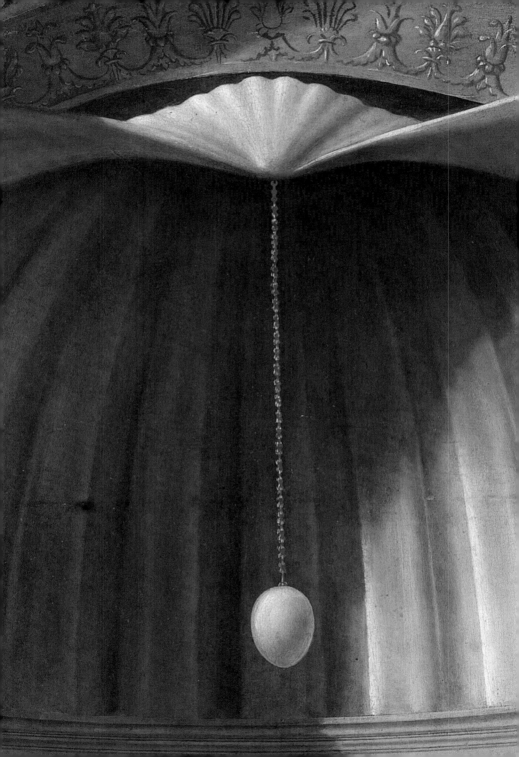

2

Piero's egg

The enormous importance that this detail assumes in the composition and in the structure of the whole panel justifies the large number of hypotheses put forward in an attempt to understand its precise significance. The giant egg that we see hanging from the chain is an ostrich egg. In the tradition of medieval bestiaries ostrich eggs had an unusual characteristic: they hatched without needing to be fertilized. Hence they alluded to the Virgin Mary's Immaculate Conception. In this context the ostrich egg may also allude to the unexpected (and therefore miraculous) birth of the duke's heir Guidubaldo, who came into the world shortly before the death of his mother Battista. According to Ronald Lightbown, however, the egg hanging in the apse has nothing to do with the Immaculate Conception, if anything it represents the Easter symbol, or Federico's hope in the final reward of the Resurrection.

Mary, *Mater Ecclesiae*

T he figure of Mary, positioned in the centre of the large church as *Mater Ecclesiae*, is the true focus of the whole composition. In fact, immediately above her head is the vanishing point from which all the perspectival lines depart, which give the painting space and depth.

The Mother of Christ and Mother of the Church is seated on a *sella plicatilis* in the centre of a dais covered with a valuable carpet, dressed in a sumptuous, purple and gold brocade gown (as though she were an empress) and wearing the traditional light blue mantle. The Madonna's hands are joined in prayer and her eyes are lowered, as she meditates on the Holy Child, lying in her lap in a tragic sleep of death that anticipates his Passion. Originally a large jewel gleamed on Mary's brow, similar to the one Battista Sforza is wearing in the portrait in the Uffizi, but this was inexplicably erased as we know from recent X-rays.

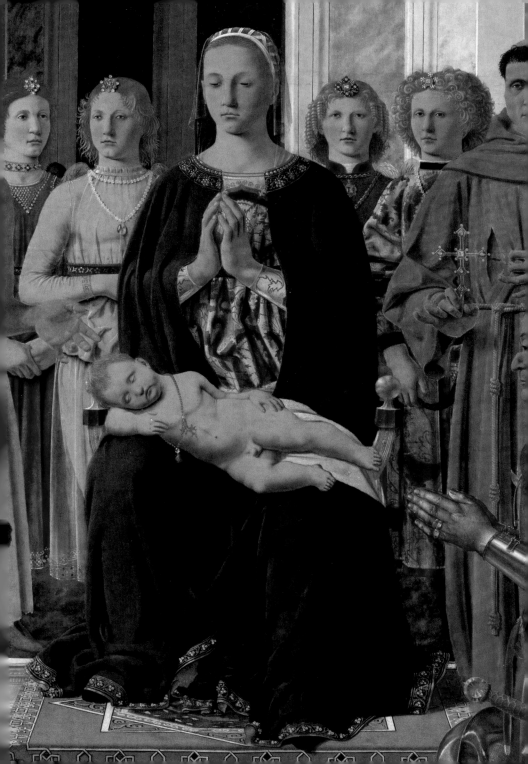

4

The sleeping Christ Child

J esus appears here sleeping in the Virgin Mary's lap.
He is wearing a coral necklace around his neck, which
is a powerful allusion to Christ's mission of salvation.
He was born to die, to suffer the agony of the
Passion for the redemption of mankind. The Christ Child
is therefore sleeping the sleep of death, in a position
reminiscent of that in the *Pietà* with the Madonna holding
the lifeless body of her Son after the deposition from
the cross. The coral necklace also indicates this dramatic
destiny, in fact, it was thought that coral was the congealed
blood of the Gorgons and thus alluded to the blood that
Christ would shed to save the world.

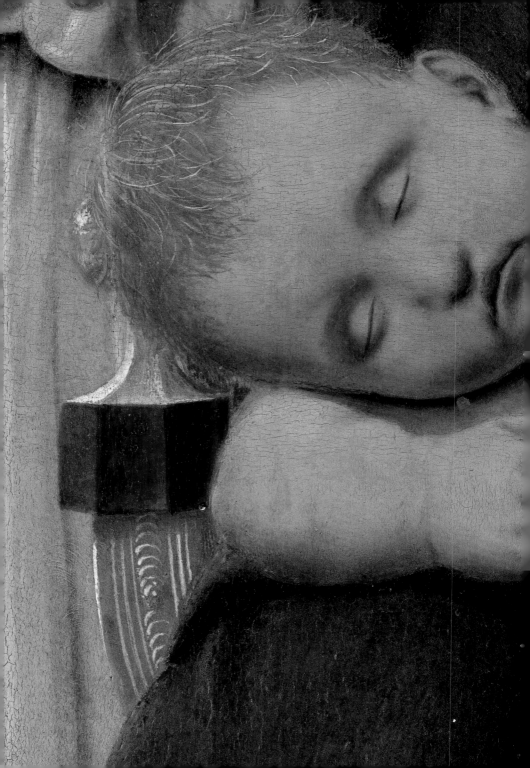

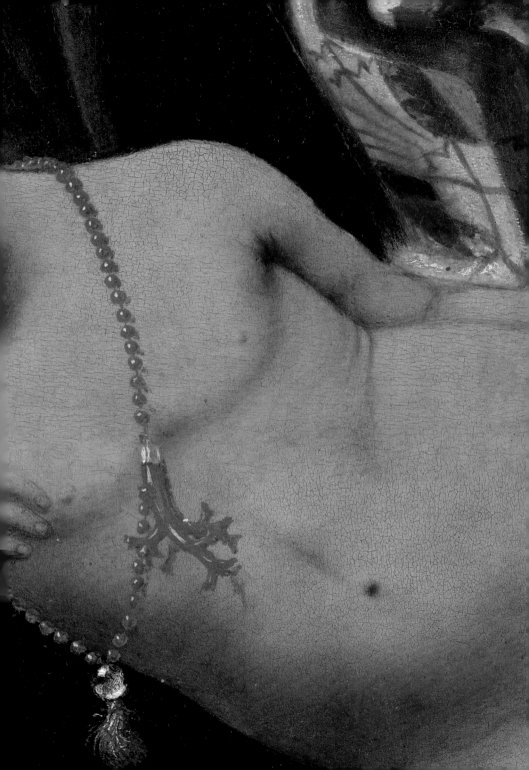

5

A magnificent carpet

Like many Italian Renaissance paintings, the *Montefeltro Altarpiece* displays an extremely luxurious detail, an oriental carpet. Only the Virgin Mary, as a sign of her elevated rank, can place her feet on such a precious object. Rare, much loved and greatly sought after, these oriental carpets reached Italy along sea routes whose main destinations were Venice and the northern Adriatic ports. It is not merely by chance that the most beautiful carpets in Italian painting are to be found in the polyptychs by Carlo Crivelli and the panels and canvases by Lorenzo Lotto, two artists who gravitated towards Venice and the coast of the Marches region. In fact, it has been recently noted that some ports in the Marches, such as Porto Recanati were important centres for the Italian trade in oriental carpets, between the 15th and 16th century. This suggests that these valuable objects were also to be found at the nearby court of Urbino, where Piero most likely admired and immortalized them in his more sumptuous paintings.

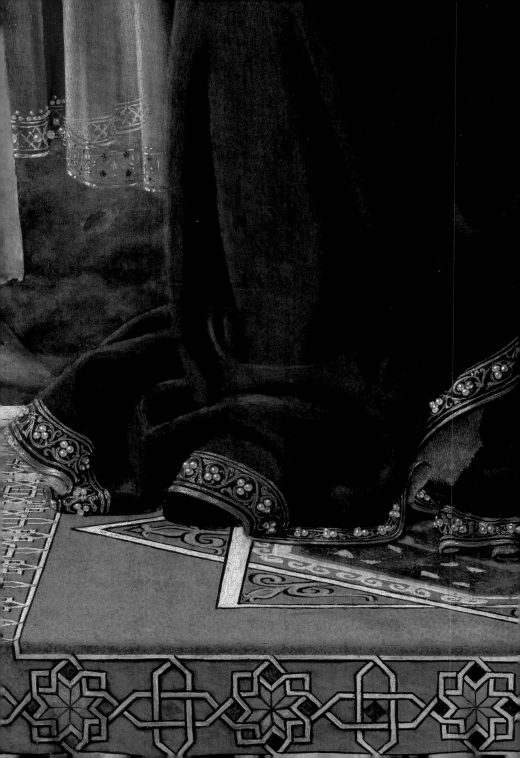

6

The profile
of an accident

Duke Federico da Montelfeltro's unmistakable
aquiline profile is one of the most well known
and immediately recognizable in Italian
Renaissance painting. In particular his very hooked nose,
broken at the top, came to be virtually the emblem of the
Duke of Urbino. Federico da Montefeltro was born in
Gubbio in 1422 and died in Ferrara in 1482. He became
Duke of Urbino in 1444 after the assassination of his
brother Oddantonio. He consolidated his power
and expanded the territory of the dukedom through his
military exploits as a condottiere, in the service of the
Popes, the Aragonese or the Sforza family. In one of
these military campaigns (or according to others, during
a tournament) the duke was wounded in the face and
disfigured, hence his unusual profile.

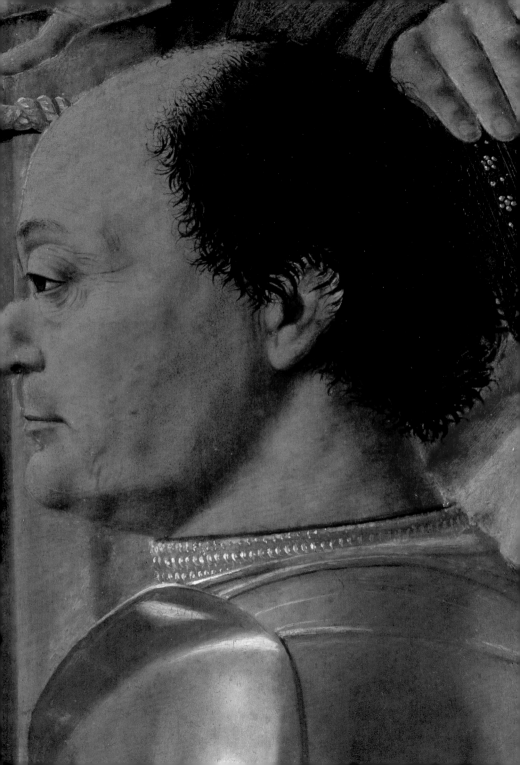

7

The duke's strange hands

E ven the most distracted viewer can't help but notice that Federico da Montefeltro's joined and ringed hands appear to be painted in a style and with a pigment that is different from the rest of the altarpiece. Recent X-ray investigations have revealed that Piero della Francesca had already completed these hands (therefore he had not left them unfinished as some scholars have claimed). Later, the duke's hands were completely reworked and they were made heavier and, more importantly, a third ring was added to the two that Piero had originally painted. By analyzing the pictorial style of this addition it has been agreed that the painter was one of the Hispano-Flemish artists active at the Urbino court during this period, namely Justus of Ghent or more likely Pedro Berruguete, who were both involved in the decoration of the Palazzo Ducale. The reason for this addition, however, remains a mystery.

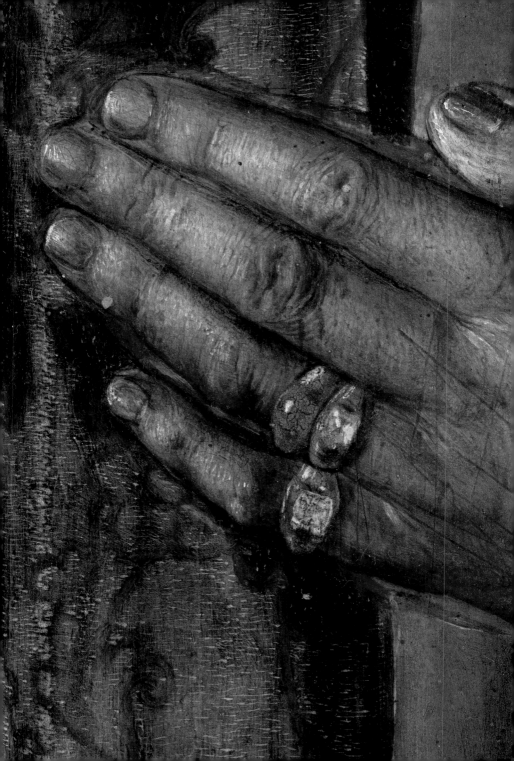

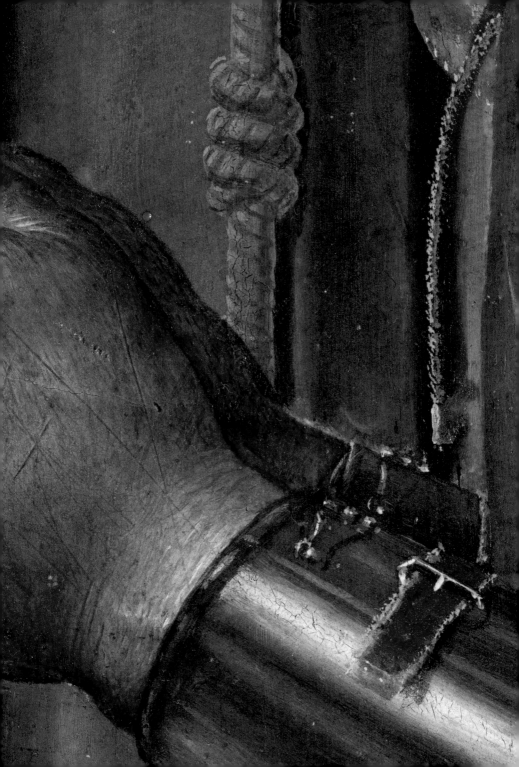

Federico da Montefeltro's armour

According to the authoritative opinion of Lionello Boccia, a great expert in antique arms, the armour that Federico da Montefeltro is wearing was made in Milan. It was probably produced in the Missaglia workshop and is datable to 1455–1460.

The scholar has suggested that it may have been a gift from the Duke of Milan on the occasion of Federico's marriage to Battista Sforza. The shining metal of the armour reflects an evocative naturalistic detail, the light from an arched window filtering into the chapel where the Sacred Conversation is taking place.

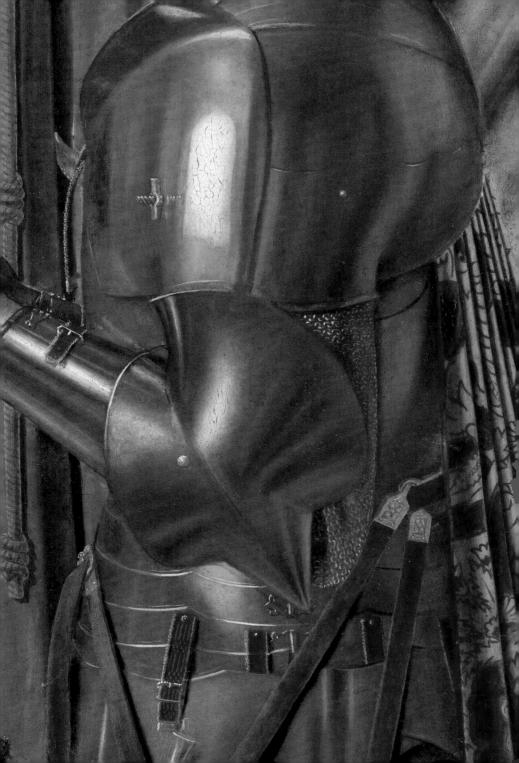

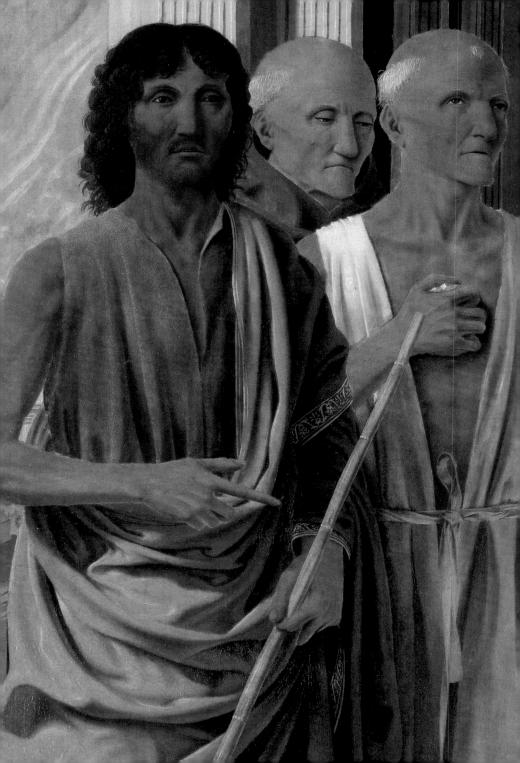

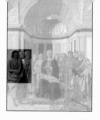

9

The three saints
on the left

Though they don't have halos, the six figures
standing in a semicircle around the silent Sacred
Conversation are saints who are all recognizable
by their iconographic attributes, and, in one case, by their
precise physical features. Let's now examine the three saints
on the left. The first, full-length figure is John the Baptist.
He is wearing the camel hair garment of a hermit and a
cloak. He is holding a wayfarer's staff in his left hand while,
as the Forerunner, he is making a very eloquent gesture with
his right, pointing to Christ, He who shall come. The second
full-length figure is St Jerome, depicted wearing the clothes
and in the attitude of a penitent who is beating his breast
with a stone. St Jerome's left hand almost brushes the head
of the Christ Child. Between these two, there is the head of
a third saint, who doesn't have any particular iconographic
attributes, except that he is wearing a Franciscan habit.
The figure, however, is easily recognizable by his facial
features. This is St Bernardino of Siena, the Franciscan
friar and great preacher famous throughout Italy, who died
in 1444, and many faithful portraits made when he was still
alive have come down to us. Piero was evidently inspired
by one of these likenesses.

10

The three saints
on the right

On the right of the composition, behind the kneeling duke, there are another three saints. They, too, can be distinguished by their iconographic attributes. The saint with the white beard holding a book is St John the Evangelist, whose iconographic attribute is the Gospel. However, occasionally critics have disputed this, preferring to see the figure as St Paul.

By contrast, the other full-length figure is definitely St Francis of Assisi, wearing the habit of the Order and with his famed stigmata. There is a third saint between these two and he is also recognizable by his specific iconographic attribute, namely the large wound on his head. This is St Peter Martyr, the first martyr of the Dominican Order, killed on the road between Como and Milan on 6 April 1252.

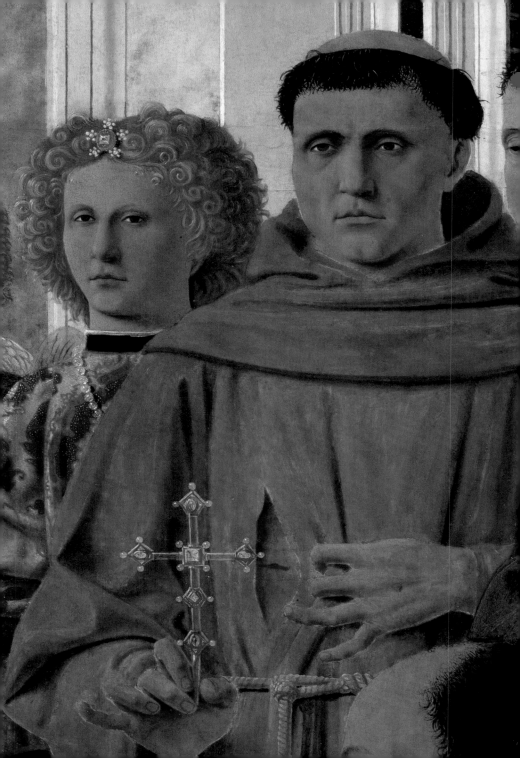

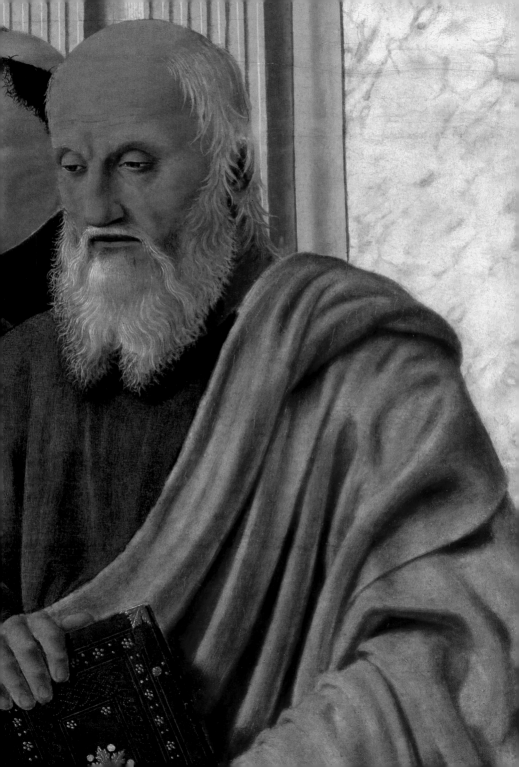

11

The stigmata
and the cross

Saint Francis' gesture showing the wound of
the stigmata in his side does not only serve to
identify the saint in the composition. Certainly
the emphasis, though measured and elegant, that Piero
places on this gesture has a deeper significance. In
medieval spirituality Francis is seen as the true *Alter
Christus*, as he who made it his mission to follow and
imitate the life of Christ, taking this to its extreme
consequence, which is exemplified by the Crucifixion.
This is why Francis not only displays the physical
wound emblematic of his complete identification with
Christ, but also holds Christ's cross, which here is
beautifully crafted in rock crystal with pearls, quartzes
and aquamarines. In medieval lapidaries rock crystal
symbolizes absolute purity and thus this precious stone
became the symbol of Christian baptism.

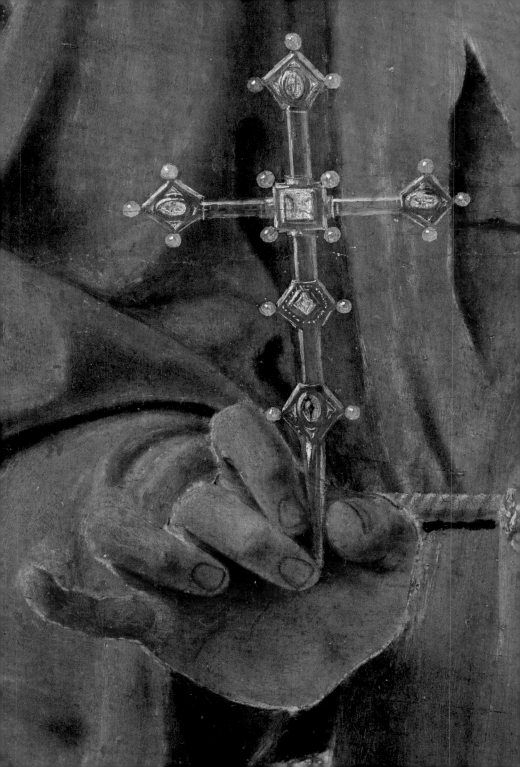

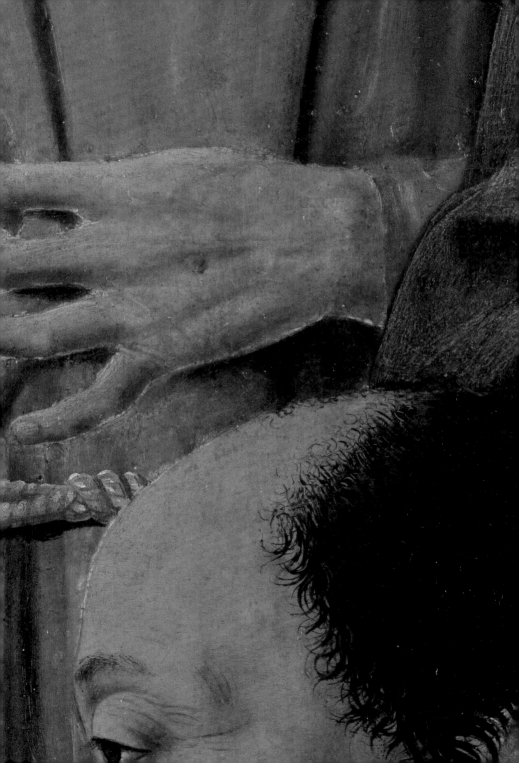

12

The books of Urbino

The book that St John the Evangelist is holding is almost certainly the Gospel. Here, however, we are invited to admire its valuable binding, made of leather, painted in lapis lazuli blue, engraved with intertwining motifs and decorated with gold studs. It is very likely that Piero is paying a tribute here to Federico da Montefeltro's extraordinary love for books, which was reflected in the splendid library that he had created on the ground floor of the Palazzo Ducale. This library – directed by the humanist Vespasiano da Bisticci – was crammed with Latin, Greek and Hebrew codices all strictly written by hand. Many of these books were also decorated with numerous magnificent miniatures, executed in the best workshops of painters and miniaturists in Ferrara, the Po Valley but especially Florence (Sandro Botticelli, Domenico Ghirlandaio, Francesco Rosselli, Attavante degli Attavanti).

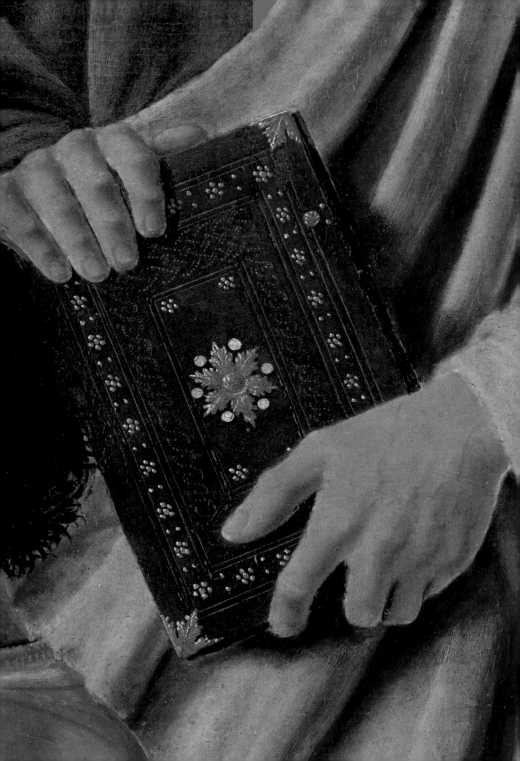

13

Archangels

I n the biblical tradition the archangels are the special
messengers of God, and as such wings are one of
their specific iconographic attributes, which can
also be seen in the *Montefeltro Altarpiece*, though they are
merely sketched on the shoulders of the four figures in the
background. The fact that there are four angels makes it
more likely that they can be identified as the four principal
archangels, Gabriel, Raphael, Michael and Uriel. Each was
assigned a particular task: Gabriel announced Salvation,
Raphael assisted the sick, Michael guided people to a good
death and Uriel announced the Last Judgement.

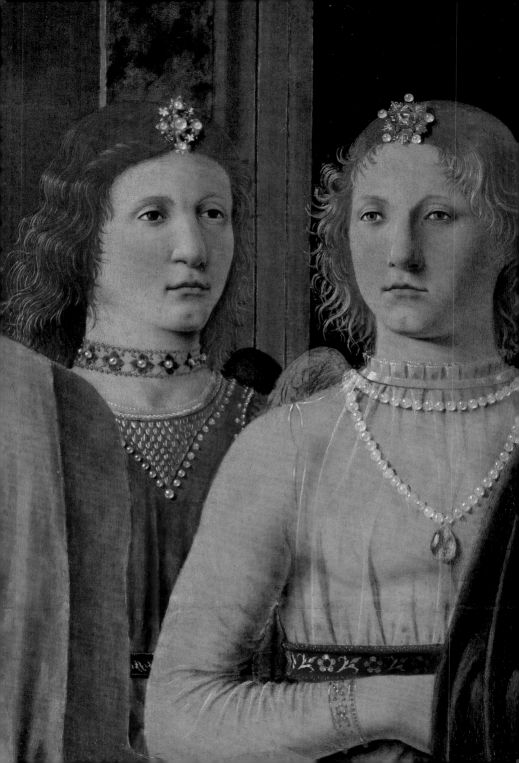

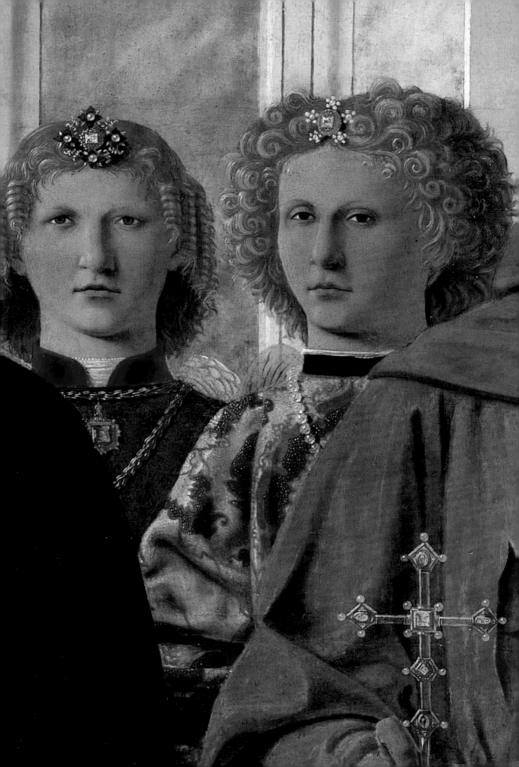

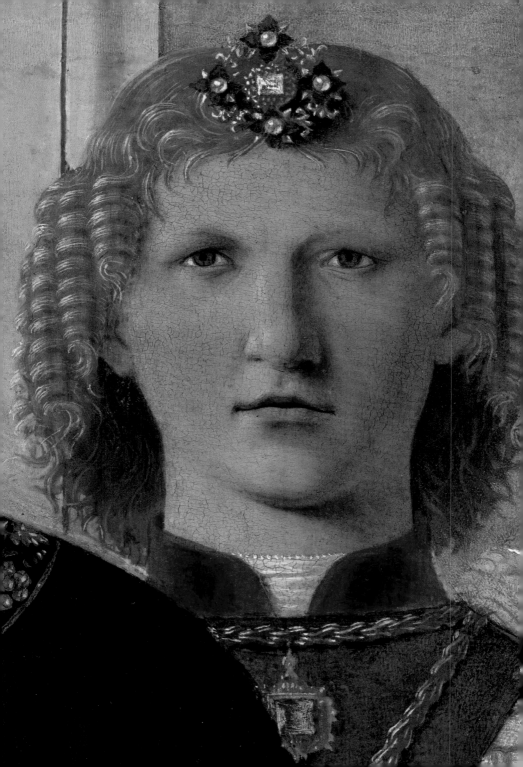

14

In search
of ideal beauty

The detail shown here is a powerful synthesis of Piero's ability to pursue and express the concept of ideal beauty. It was the attainment of this timeless perfection that struck great art historians like Bernard Berenson, Adolfo Venturi and Roberto Longhi who began to rediscover Piero from the early 20th century on. Berenson in particular was enraptured before "the painter's impersonality, the absence of emotions, the quality of things" and he observed that "the solemn figures, the calm actions, the severe landscapes exert their maximum power over us". While Roberto Longhi coined a very pithy sentence that is still extremely relevant today to describe Piero's greatness: "Piero is the perspectival synthesis of form and colour".

15

Piero's gems

The *Montefeltro Altarpiece*, like other works by Piero, is full of decorative details and fascinating pieces of precious jewellery. This is an enlargement of one of the *broches* or hair clips placed in a prominent position on the heads of all four archangels, who also wear chokers of gold and precious stones, pearl necklaces with pendants, and gold mesh chains. The piece of jewellery enlarged here consists of five pearls (the largest is placed in the centre) mounted on a gold support in the shape of a corolla with four small enamel flowers alternately coloured white and blue. The precision of technique and materials with which the jewellery in the *Montefeltro Altarpiece* is rendered suggest that these pieces really existed and were part of the extremely rich legacy of the dukes of Urbino.

PIERO DELLA FRANCESCA
HIS LIFE AND TIMES

1412–1413 Piero della Francesca is born in Borgo San Sepolcro (now Sansepol-cro) circa 1412–1413 to Benedetto de' Franceschi and Romana di Pierino, and grew up in the comfort of a prosperous merchant family, where he developed his bent for accounting, mathematics and the rudiments of Euclidean geometry.

1432 According to Vasari, Piero began to paint at around the age of fifteen. From 1432 to 1438 he is an assistant of Antonio d'Anghiari, with whom he executes minor works such as the decoration on coats of arms and flags.

1439 Piero della Francesca is in Florence working with Domenico Veneziano on the frescoes in the Chapel of the High Altar in the Church of Sant'Egidio, a cycle dedicated to the Virgin Mary, which was later destroyed. This Florentine experience is crucial to Piero's artistic development, since here he has the opportunity of studying Leon Battista Alberti's pictorial, architectural and perspectival theories and seeing them applied in the paintings of Masaccio and Paolo Uccello, and in Brunelleschi's buildings. Like Domenico Veneziano, the young artist focuses particularly on the study of light and chromatic harmony. He follows closely the discussions of the 1439 Florentine Council on the fate of threatened Byzantium and on the need to unite the Greek Church and the Roman Church.

1442 He is once again documented as being in Borgo San Sepolcro, where he permanently resides, though his profession takes him away on many journeys. In 1440 the Florentines surrendered the Borgo to Pope Eugene IV.
In Florence, Beato Angelico completes the fresco decoration of the Monastery of San Marco.

1445 He receives his first important commission in Borgo San Sepolcro: the execution of a large polyptych for the local Brotherhood of Mercy. The work, which was completed fifteen years later, is now in the Museo di Sansepolcro. It is likely that between 1445 and 1450 Piero was executing for the Camaldolensians of Borgo San Sepolcro the *Baptism of Christ*, now in the National Gallery, London. This is stylistically very similar to the Florentine *pittura di luce* (painting of light) works and is rich in references to the theological discussions of the Council.
Sandro Botticelli is born in Florence.

1450 Piero is in Ferrara where he paints a fresco cycle (now lost) in the Church of Sant'Agostino and has an opportunity to study Flemish painting through the works by Rogier van der Weyden in Duke Borso d'Este's collection. In 1450 he signs and dates a small panel depicting the *Penitent St Jerome* (Berlin, Gemäldegalerie).
The construction of the Tempio Malatestiano designed by Leon Battista Alberti begins in Rimini.

1451 Piero is summoned to Rimini by Sigismondo Pandolfo Malatesta and paints his portrait in profile (Paris, Louvre) and a votive fresco in the Chapel of Relics in the Tempio Malatestiano, depicting the Lord of Rimini worshipping his patron saint Sigismondo. The painting is dated 1451.

1452–1454 After the death of the painter Bicci di Lorenzo in 1452, Piero della Francesca is summoned to Arezzo to continue the decoration of the Chapel of the High Altar in the Church of San Francesco that the former master left unfinished. In around five years, Piero completes

his masterpiece, *Legend of the True Cross*, inspired by *The Golden Legend* by Jacobus de Voragine, which is pervaded by references to the fate of Byzantium (which fell into the hands of the Turks on 29 May 1453) and the Christian world's consequent desire for revenge. In the same period he paints the *Madonna of the Birth* at Monterchi, his mother's birthplace, followed by the *Resurrection*, the powerful fresco and emblem of the city of Sansepolcro, now in the local Museo Civico.

In 1452 Frederick III was crowned Holy Roman Emperor in Rome and Leonardo was born in the village of Vinci near Florence.

In 1454 the Peace of Lodi heralded a period of political stability in Italy.

1459 He is documented as being in Rome and working on the decoration of the Vatican apartments of Pope Pius II Piccolomini (elected to the papal throne in 1458). Later his paintings were destroyed and Raphael's took their place. Many experts date his mysterious *Flagellation*, now in the Galleria Nazionale delle Marche in Urbino, to his return from Rome. In Florence, Benozzo Gozzoli frescoes the Chapel of the Magi in Palazzo Medici Riccardi.

1460 From 1460 on, the painter is again in Borgo San Sepolcro, where he completes the *Polyptych of the Madonna della Misericordia* (Sansepolcro, Museo Civico) and a second polyptych, commissioned by the Augustinian fathers in 1454, later dismantled and dispersed. The eight sections that have been recovered to date are now in the Museo Poldi Pezzoli, Milan, the National Gallery, London, the Museu Nacional de Arte Antiga, Lisbon, the Frick Collection, New York and the National Gallery, Washington. Leon Battista Alberti begins construction on the Church of San Sebastiano in Mantua.

1468 The painter finishes the polyptych executed for the Augustinian nuns in Perugia (now in the Galleria Nazionale dell'Umbria).

1469 Piero is in Urbino, as the guest of Giovanni Santi (Raphael's father), and enters the good graces of Duke Federico da Montefeltro. He executes the famous Uffizi Diptych for him (with his portrait and that of his wife Battista Sforza on the front and the triumphal allegories of Fame and Chastity on the back) and the imposing *Montefeltro Altarpiece* for Federico's mausoleum in Urbino, now in the Pinacoteca di Brera.

1471–1478 On his return to Borgo San Sepolcro, Piero continues to work for the Urbino court during the following years. This is evident from the *Montefeltro Altarpiece* in the Pinacoteca di Brera (perhaps completed by the end of 1474) and the *Madonna di Senigallia*, (Urbino, Palazzo Ducale), datable to circa 1478.
In 1471 Sixtus IV della Rovere is elected pope. Albrecht Dürer is born in Nuremberg. In 1474 Andrea Mantegna completes the frescoes in the Camera degli Sposi in the Palazzo Ducale in Mantua; in 1475 Michelangelo is born in Caprese.

1480–1490 Piero spends the last ten years of his life writing treatises on arithmetic and geometry: *Libro d'Abaco* (*Abacus Treatise*), *De Prospectiva pingendi* (*On Perspective for Painting*), *Libellus de quinque corporibus regolaribus* (*Book on the Five Regular Solids*), holding public offices (in 1482 he is head of the priors of the Brotherhood of St Bartholomew) and painting for the close family entourage what is thought to be his last work, the very damaged and perhaps unfinished *Nativity* now in London.

1482 Piero is once again in Rimini where he rents a house with a garden and a well from the gentlewoman Giacosa, widow of Ganimede Borelli. Leonardo da Vinci is in Milan working at the court of Ludovico the Moor. Also in Milan, Bramante begins work on the construction of the Church of Santa Maria presso San Satiro, while Botticelli in Florence paints *La Primavera*.

1487 Piero della Francesca, "sound in mind, in intellect and in body", writes his will with the notary Lionardo di ser Mario Fedeli in Borgo San Sepolcro.
In Milan, Leonardo works on the lantern of the cathedral, while in Rome Filippino Lippi is executing the frescoes in the Carafa Chapel in the Church of Santa Maria della Minerva.

1492 Struck by blindness, Piero della Francesca dies in Borgo San Sepolcro on 12 October 1492, the day when Christopher Columbus discovers America. The painter is buried in the Chapel of San Leonardo in the cloister of the Abbey.
In Florence, Lorenzo il Magnifico dies and Girolamo Savonarola seizes power. The system of Italian alliances ratified by the Peace of Lodi breaks down.

Printed in Italy
by 24 ORE Cultura, Pero (Milan)
February 2012